WONDERS OF THE WORLD
DOT-TO-DOT

CHARTWELL
BOOKS

Quarto is the authority on a wide range of topics.
Quarto educates, entertains, and enriches the lives of our readers—
enthusiasts and lovers of hands-on living.
www.quartoknows.com

This edition published in 2016 by
CHARTWELL BOOKS
an imprint of Book Sales
a division of Quarto Publishing Group USA Inc.
142 West 36th Street, 4th Floor
New York, New York 10018
USA

10 9 8 7 6 5 4 3 2

ISBN-13: 978-0-7858-3449-6

Printed in China

Puzzles by Jeff Miller
Cover and interior design by Melissa Gerber
Photo research by Dawn Cusick

CONTENTS

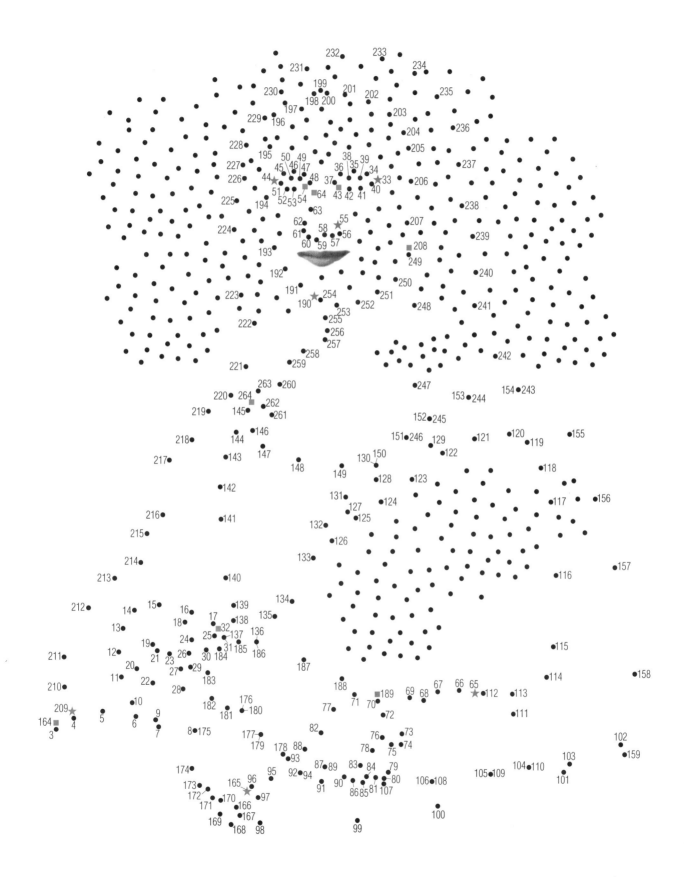

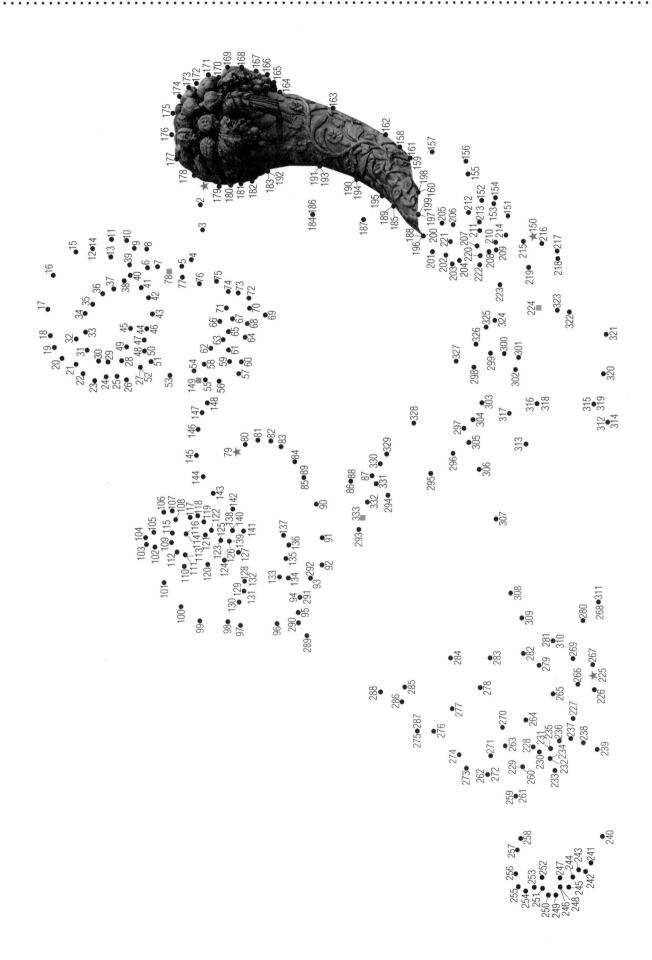

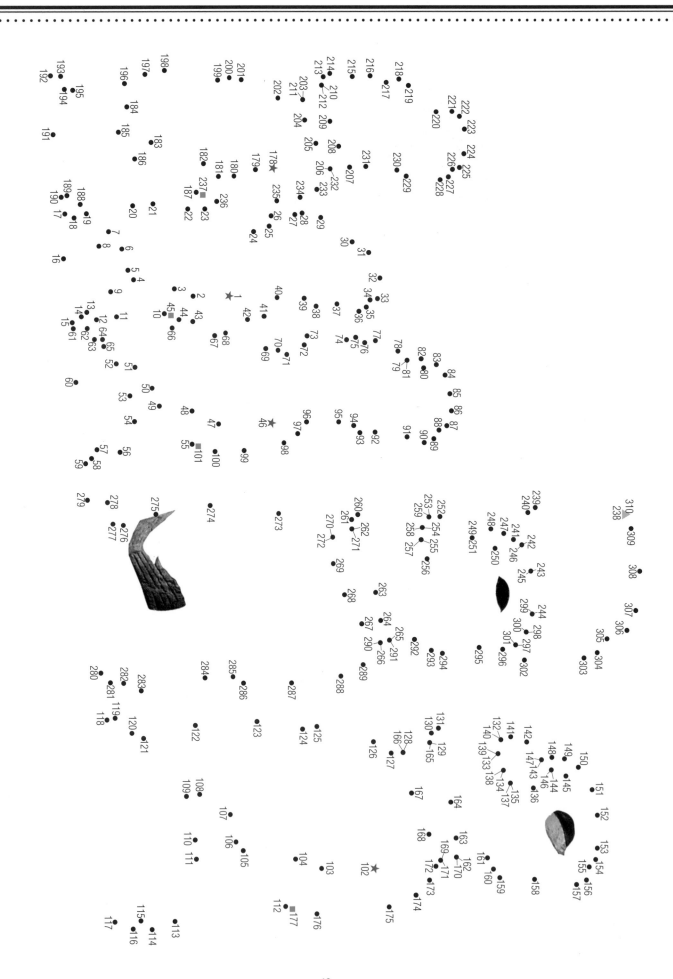

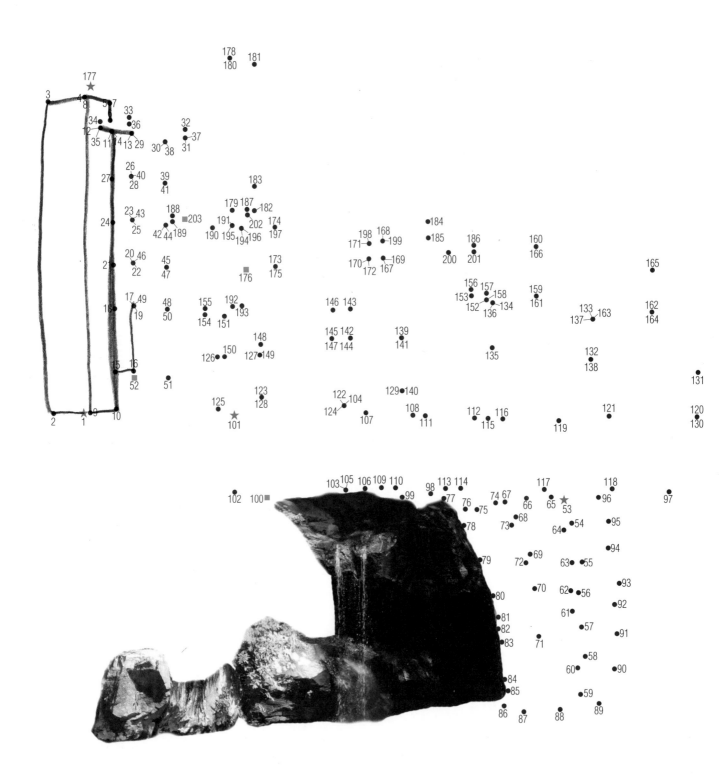

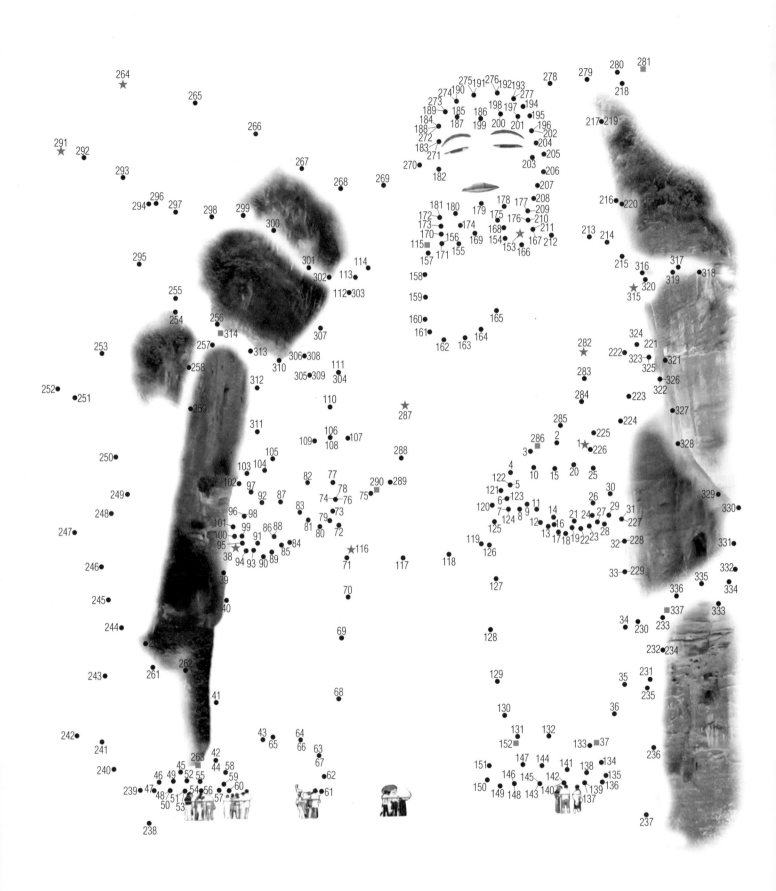

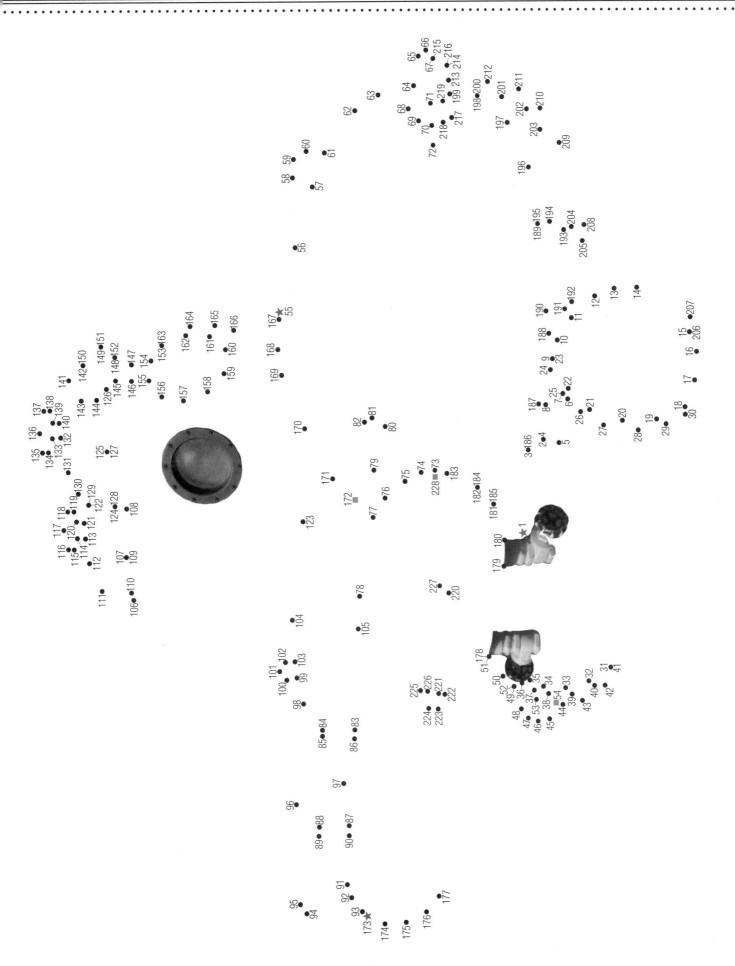

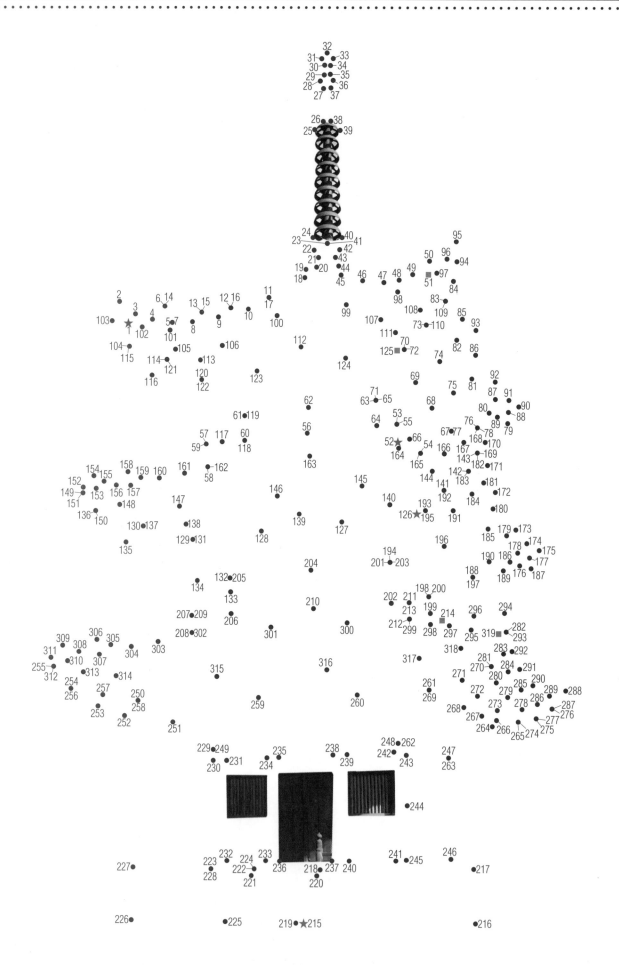

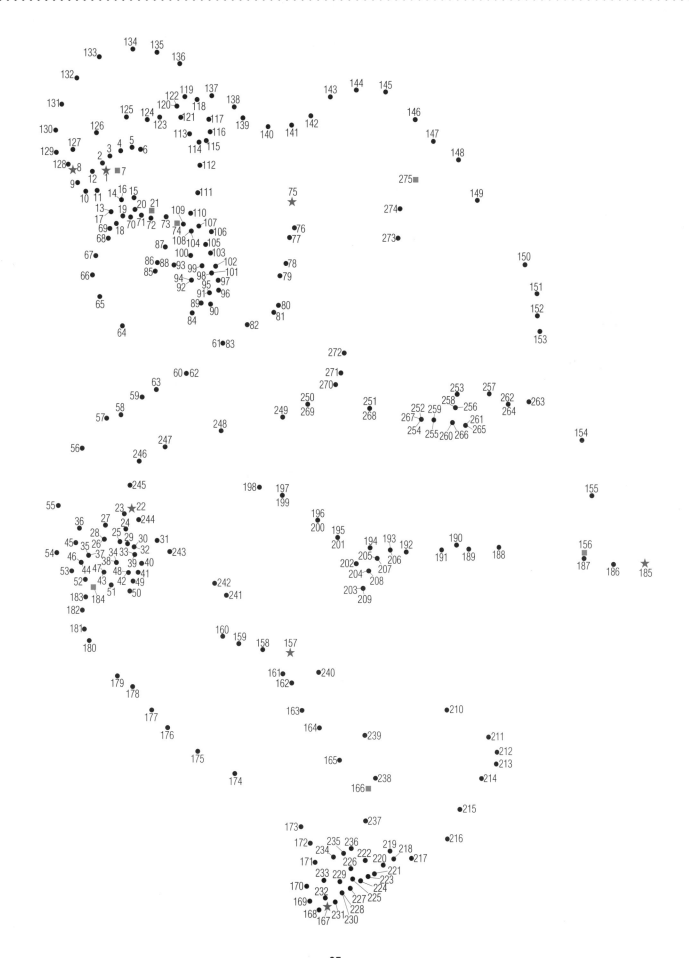

21
22 17
18

23 1 2 3 16
24 15
26 25 14
27 13
12

28 93 92 91 90 89 88 87 11
29 86

30 4 5 6 7 8 9 10 85
31 78 79 80 81 82 84
32 65
77 73 72 71 70 69 83
75 74 64
76 68 66
63 67
62
61
60

103
141
101 113
111 115 95
107 105 140 97
99 139 138 137
109 136
135
116 134
133
132
130 131
129 117
128 118
119
127 120
39 126 96 59
40 106 125 121 58
41 112 57
102 124 110 114 122 56
42 94 55
43 104 100 108 123 98 54
44 45 46 47 51 52 53
48 50
49

20
19

40

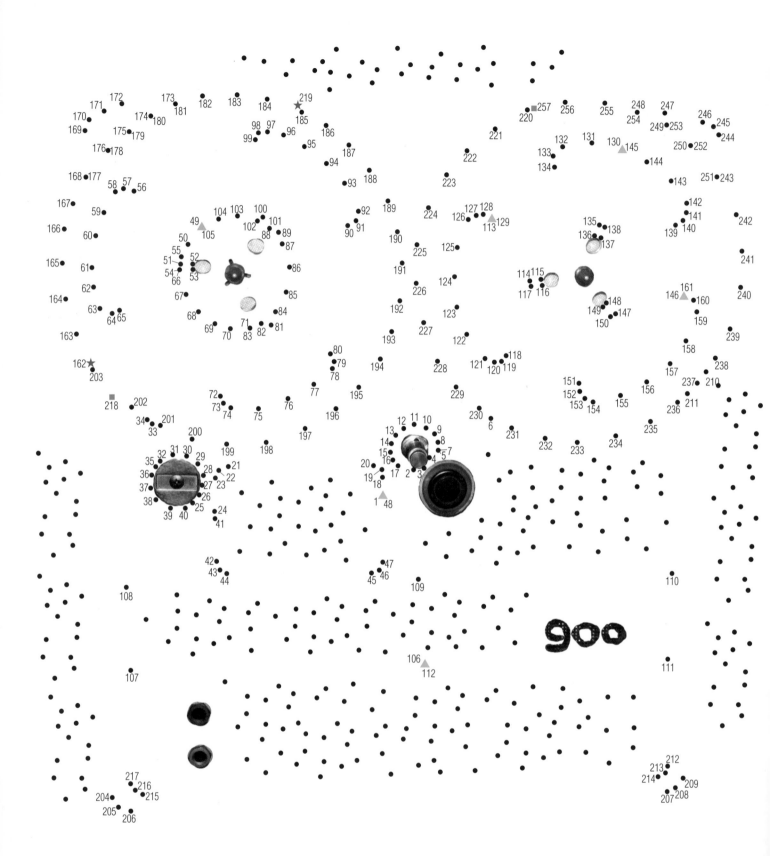

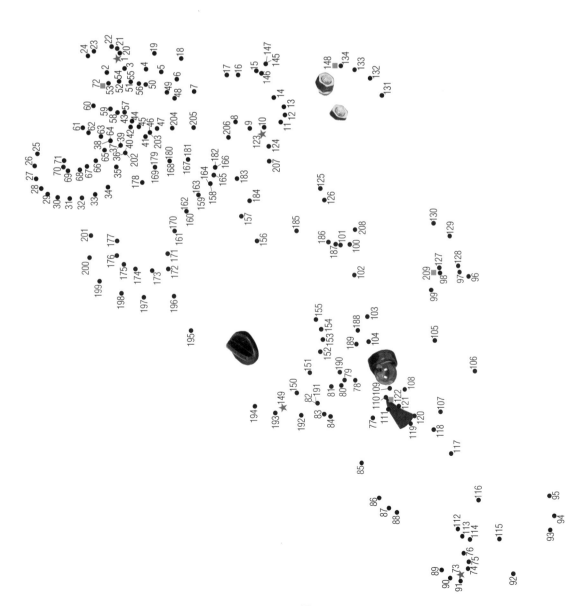

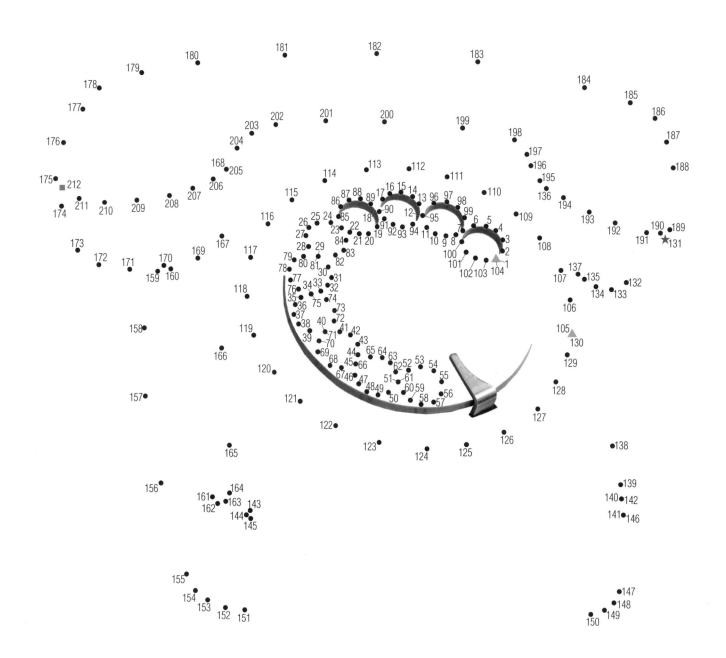

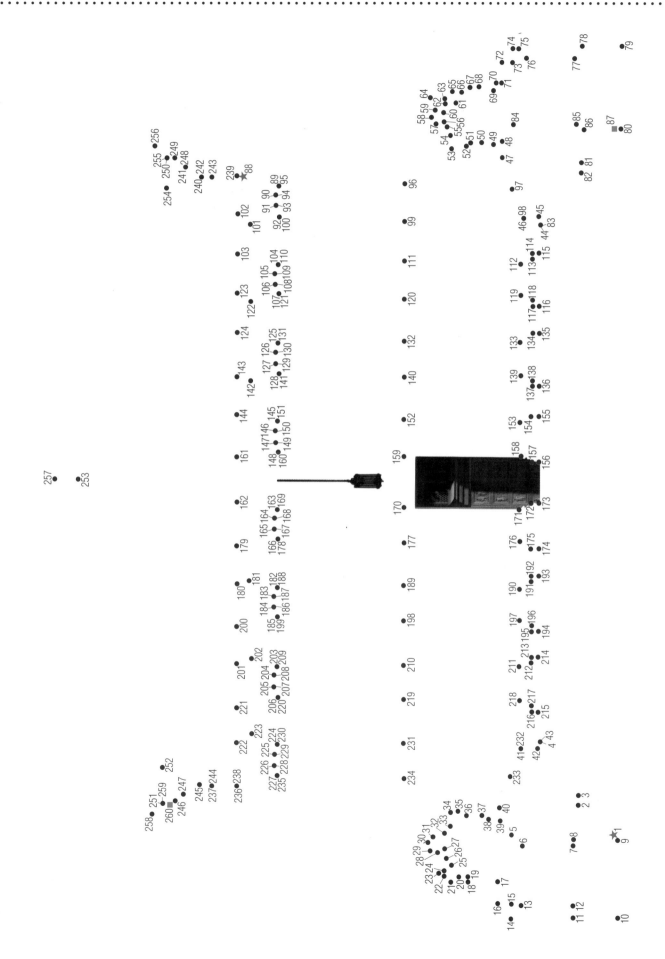

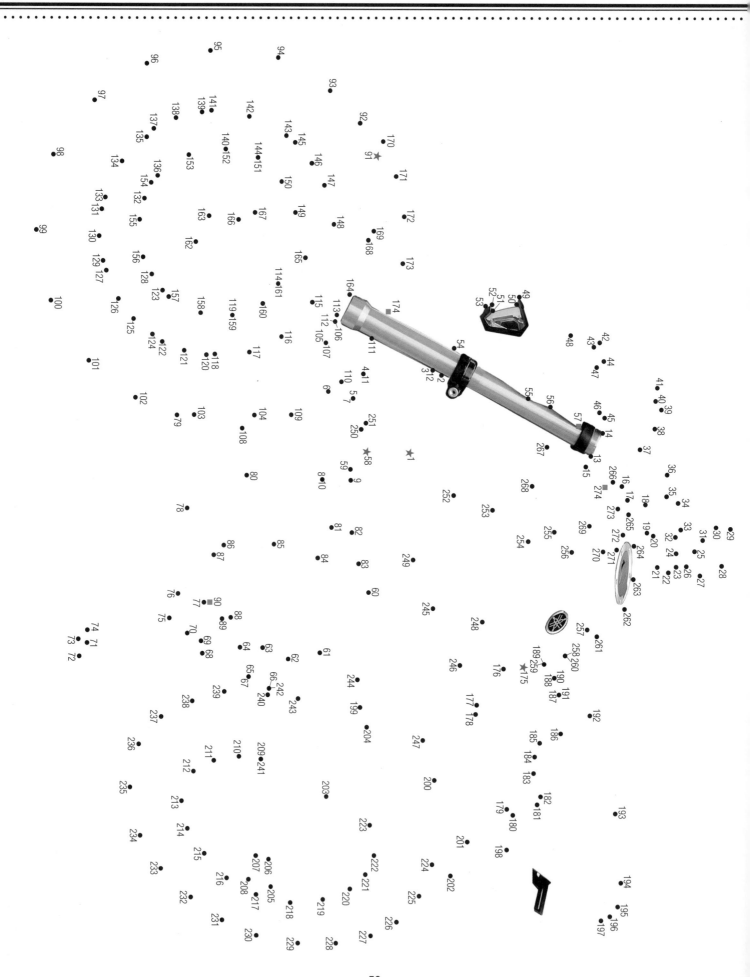

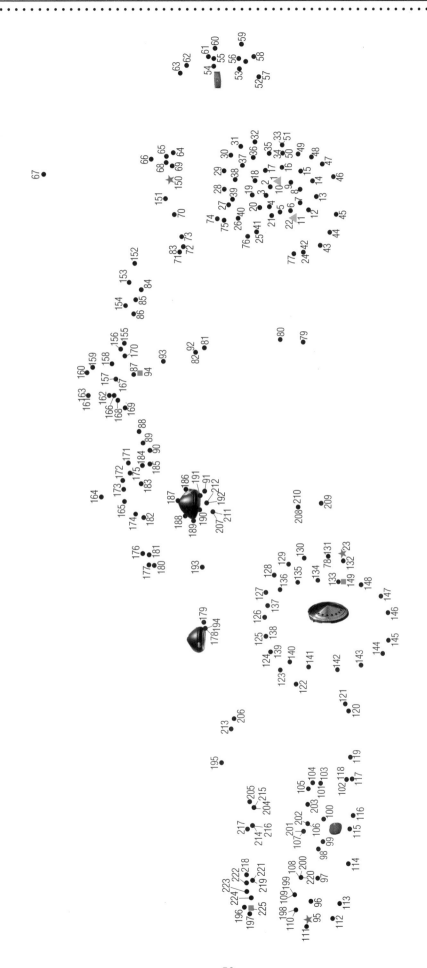

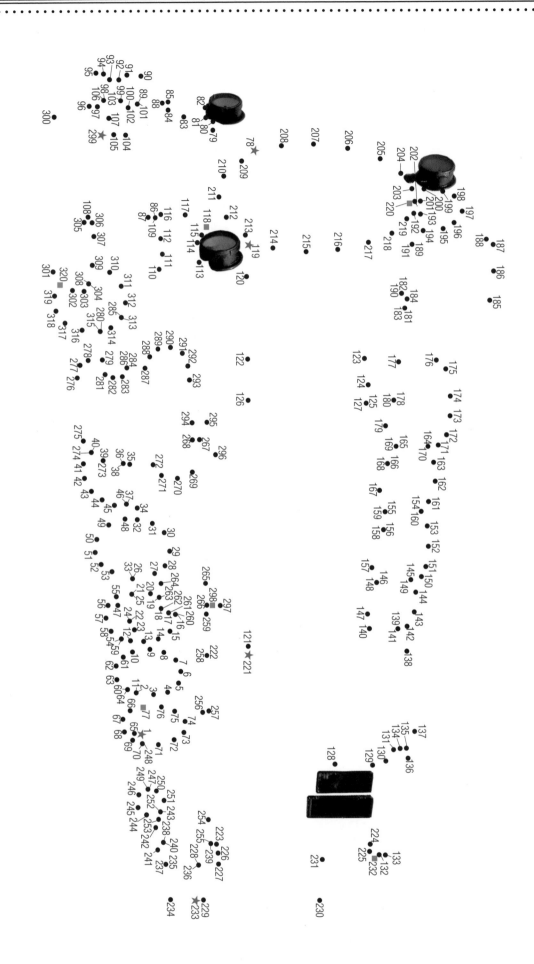

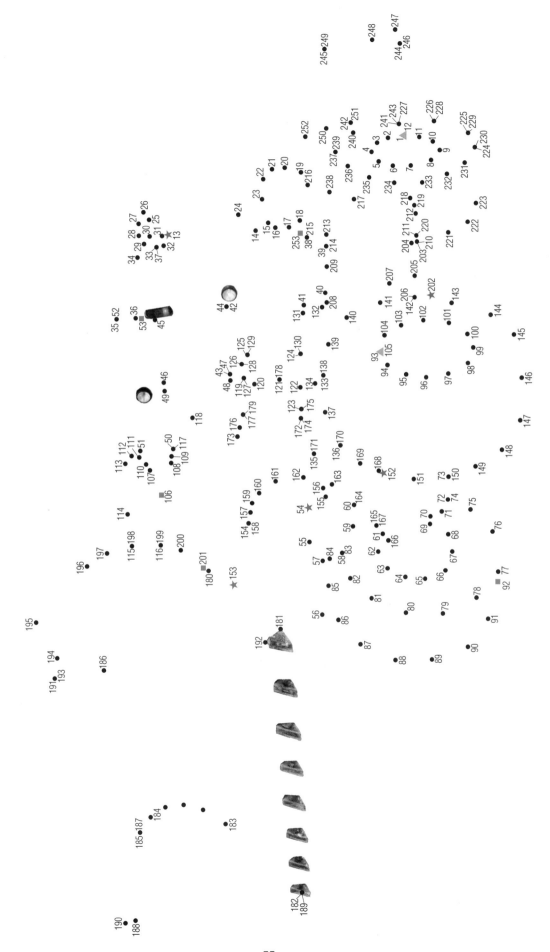

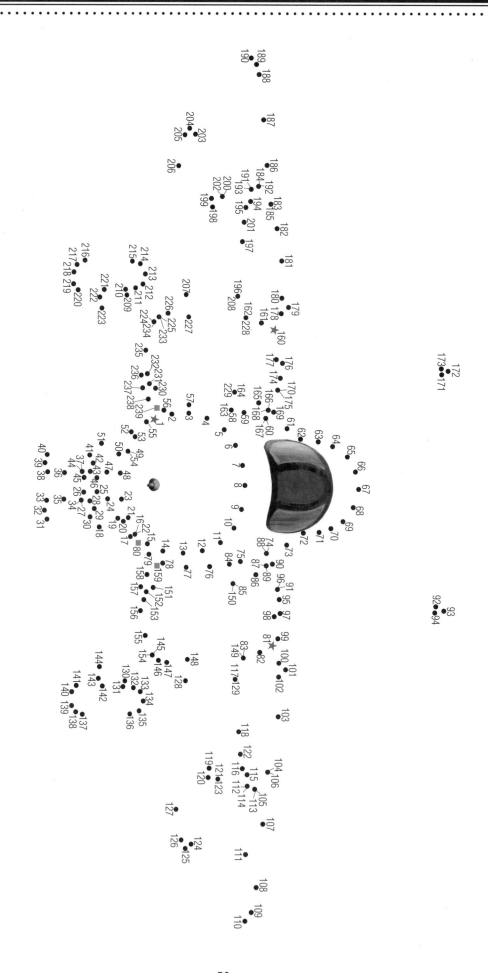

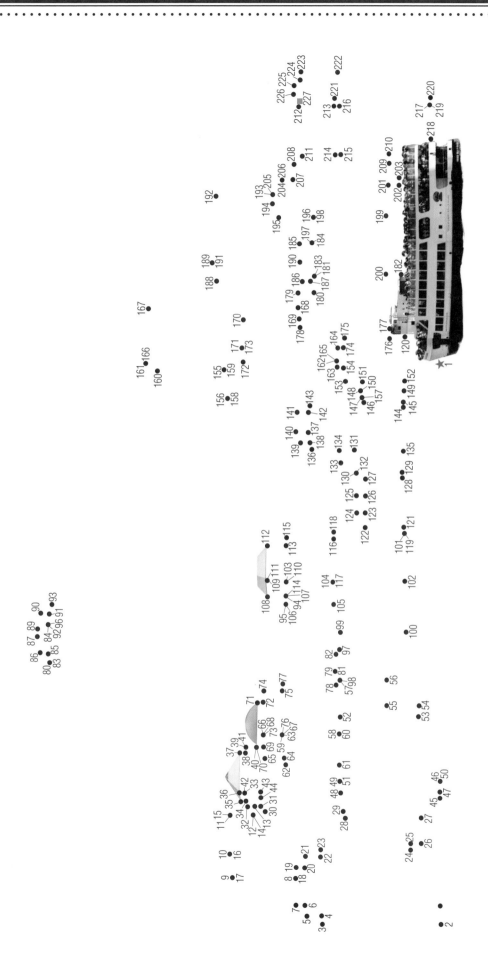

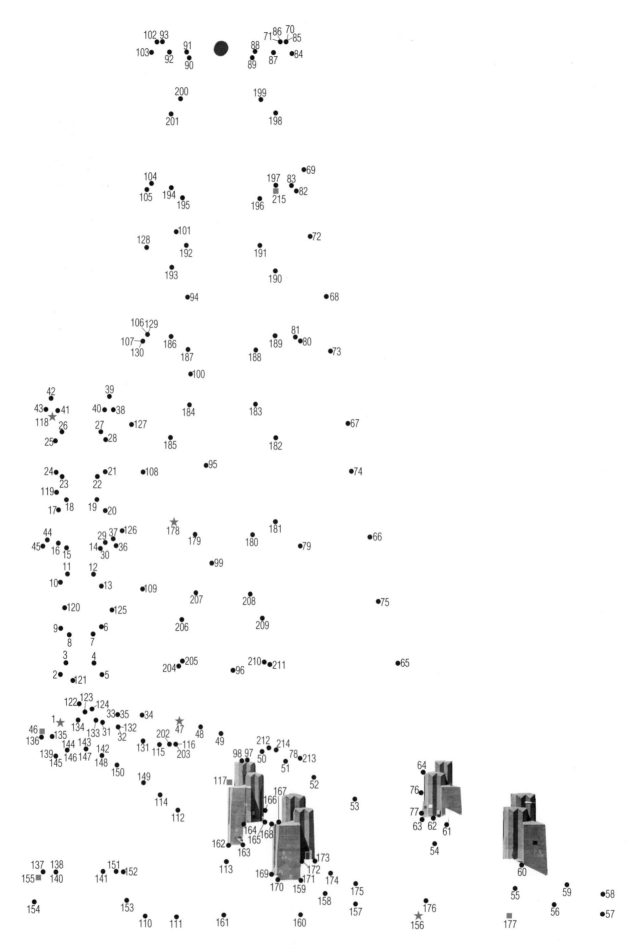

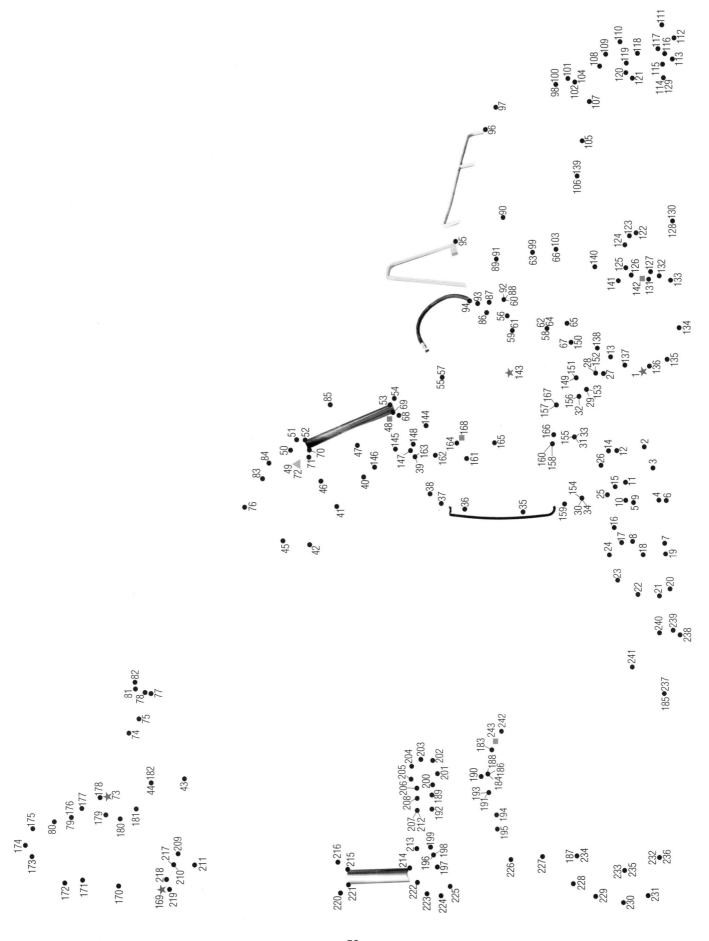

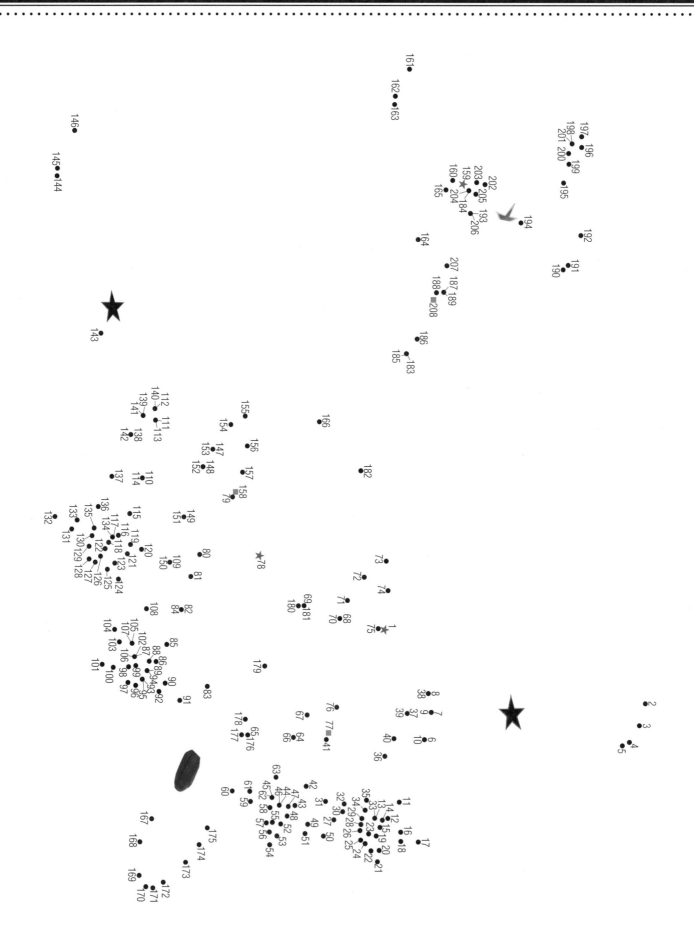

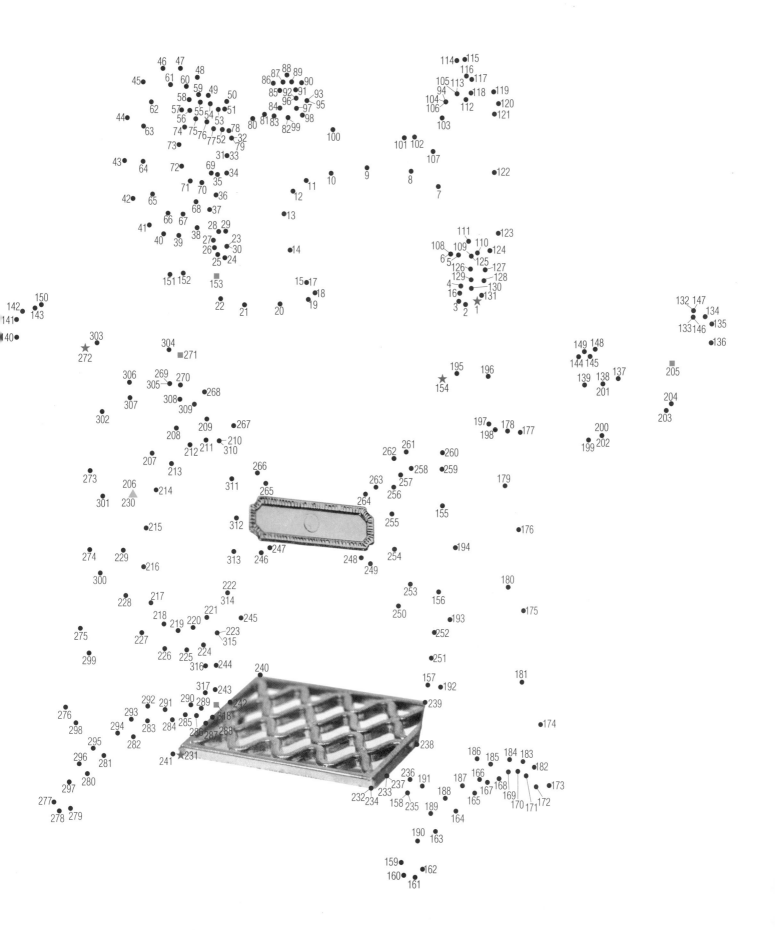

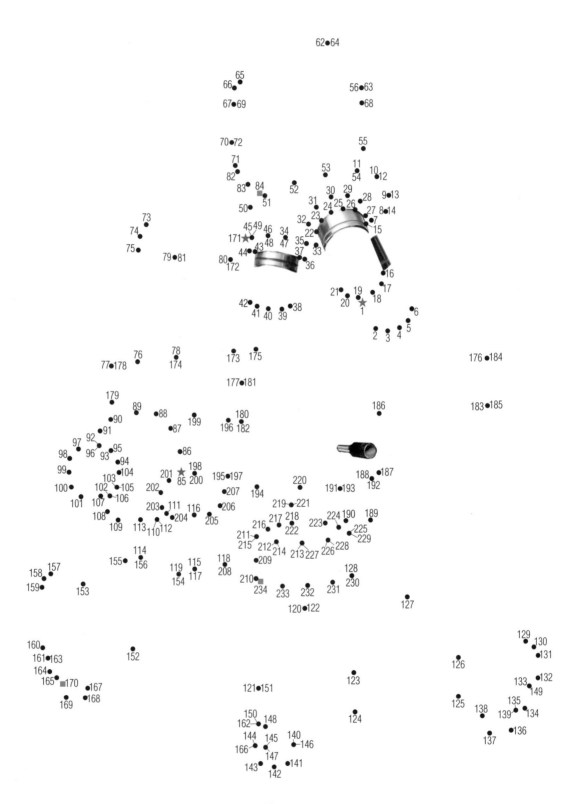

5 6 9 10

1★

■14

172 56 171 52 51 47●105 104
173● 57●170 53● ●50 48● ●106 ●103
 ●55 46
174● 58●169 2 54● 4 7 8 11 49 13 45 ●102
 3 59● 22 16 27 44 12 107
29▲63 62● 19 42● 41 ●40
30● 31●●61 23 60● ●43 26 ●38 ●39
 32 33 36 37

153 144
24■ ★25

154 152 145 143

155 151 146 142 100 99
167●175 166●168 150 147 141 136 108 101
164●176 163●165 156 140 135
 139 138●137 97 96
 132● 134 133 109 98
 131● 130 128 129 111 110
 93 112
 113

127● 114
126● ●115
125 116

■28

161 160 34 35 88 92 91
177 162 124● 117 94 95
21★ 149 77 123● 118
 68 148 122● 119
178● 179■ 157 158 82 83 86 87
 159 67 69 75 76 74 81 121● 120 90
 64★ 70 73 78 84 85

■20 ■17 ●80

66● ●79

65●

★ ★15
18

71 72

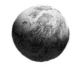

4●

5●

●6

●7

3●

●8
●110

31 32 33 34 35
16 15 14
17 13 36
18 30 41 12
19 29 42 40 39 38 11 37
28 43 10
20 44 81 9
1 27 82 109
117 21 26 83 108 106
22 45 107 105
23 25 46 84 85 104
48 47 24 78 77 76 86 89 91
79 80 87 88 90 103
64 73 75 92 102
49 65 72 74 93 100
71 96 95 94 101
63 66 70 97 98 99 118
51 147 146 145
50 52 67 69 150 148 119
54 53 68 149 120
55 62 180 151 143 144
59 61 152 142 121
56 154 141 153
57 179 155
58 60 178 156
177 159 158 157 140 124 123 122 126
176 160 161 139 125 127
175 162 138 128
172 163 135 129
174 173 164 137 136 130
171 165 134 131
169 170 166 133
168 167 132

●111

115●

2●
116●

49●

114●

113●

●112

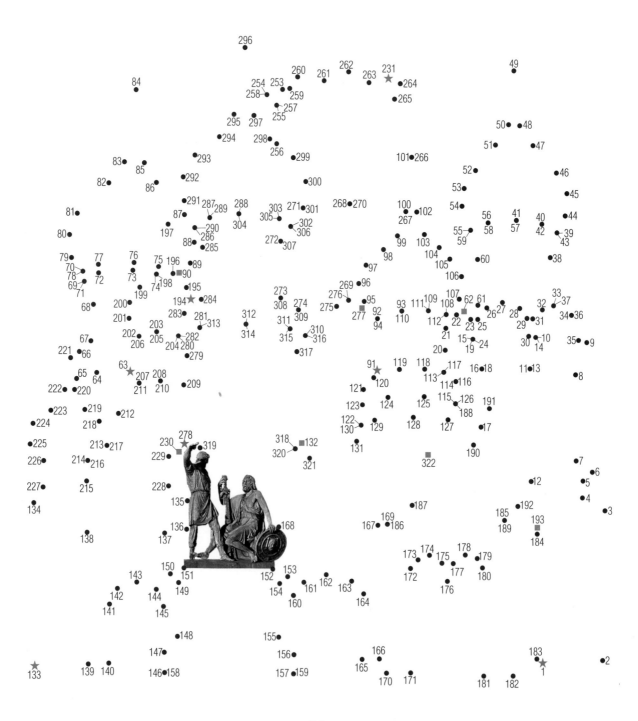

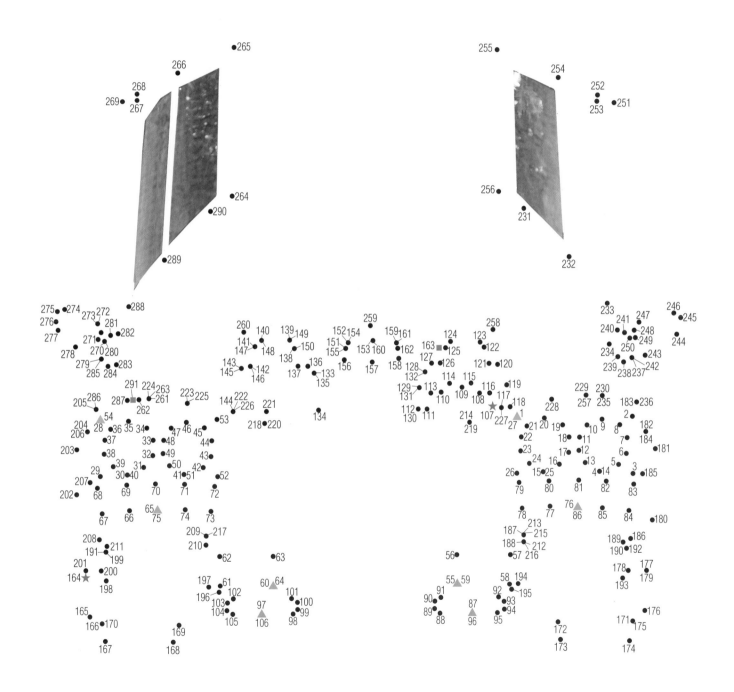

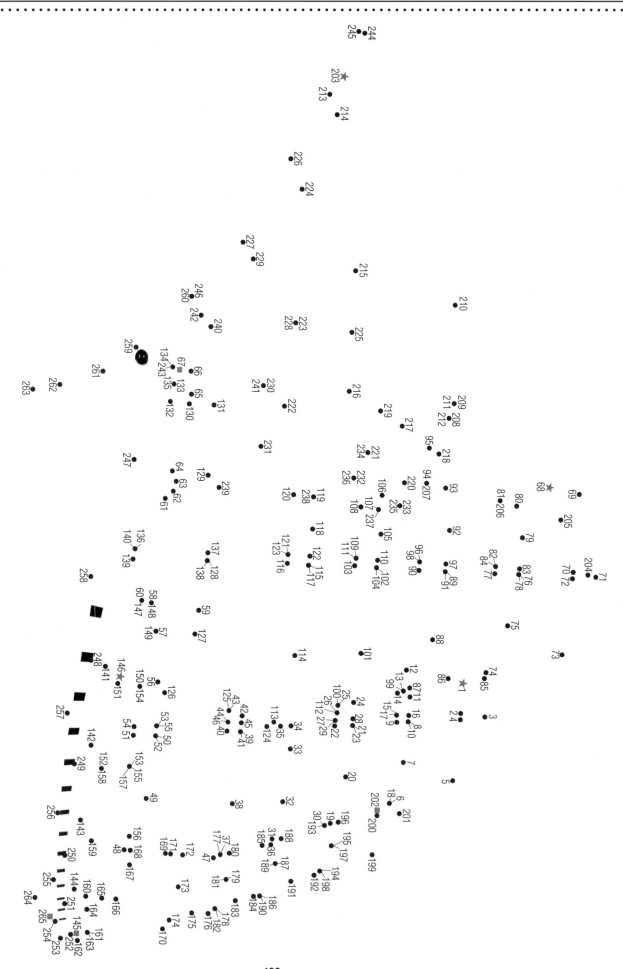

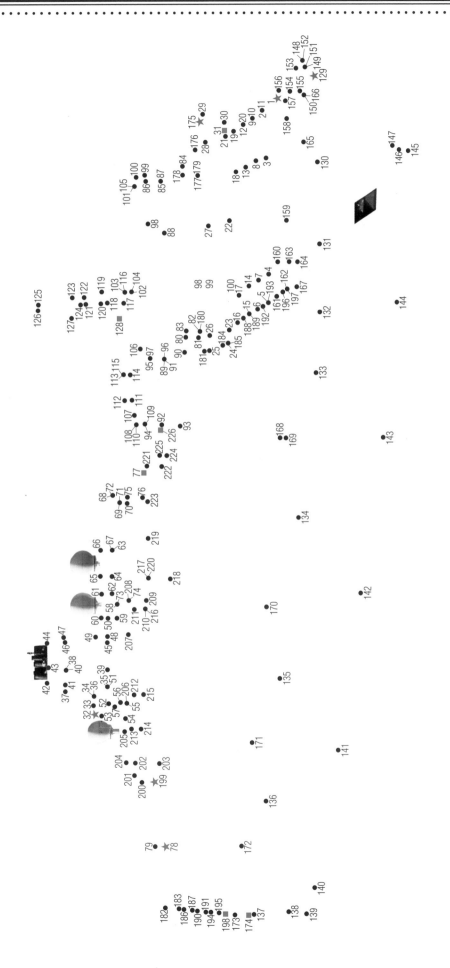

CHALLENGING ANSWERS

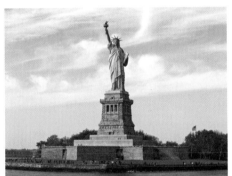

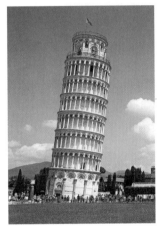

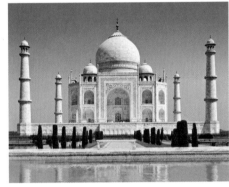

PAGE 4

PAGE 5

PAGE 6

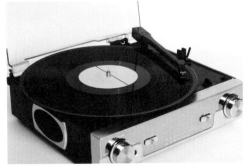

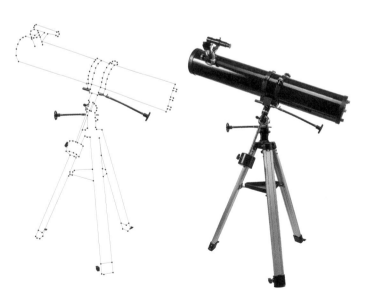

PAGE 7

PAGE 8

CHALLENGING ANSWERS

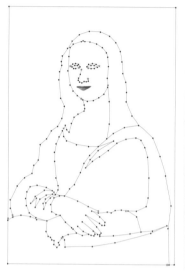 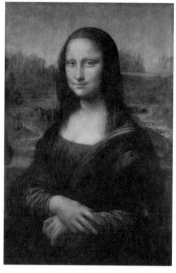

PAGE 9

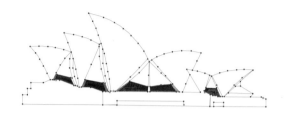
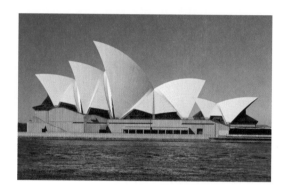

PAGE 10

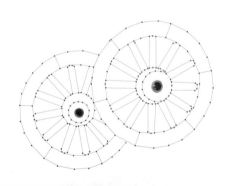

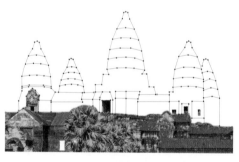

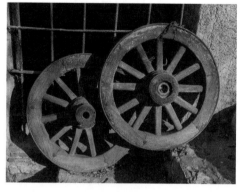 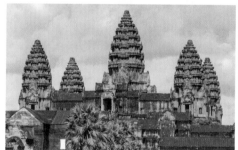

PAGE 11

PAGE 12

PAGE 13

CHALLENGING ANSWERS

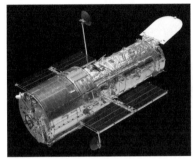

PAGE 14

PAGE 15

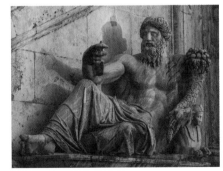

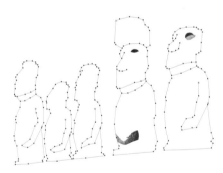

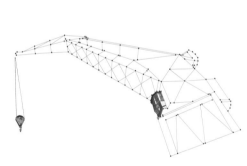

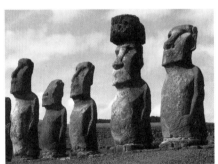

PAGE 16

PAGE 17

PAGE 18

CHALLENGING ANSWERS

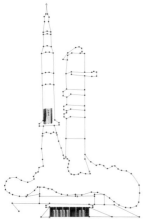
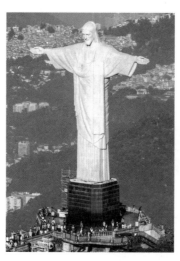

PAGE 19

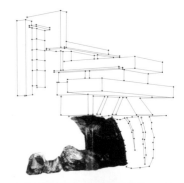
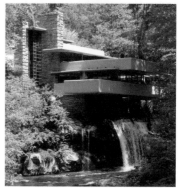

PAGE 20

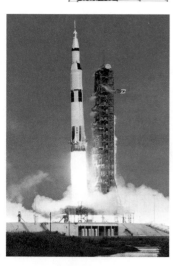
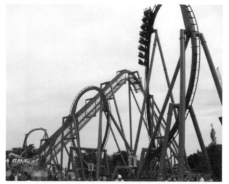
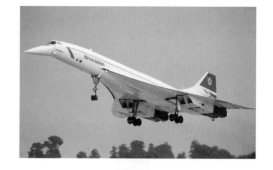

PAGE 21

PAGE 22

PAGE 23

CHALLENGING ANSWERS

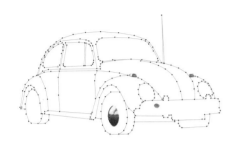

PAGE 24

PAGE 25

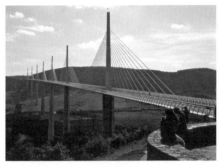

PAGE 26

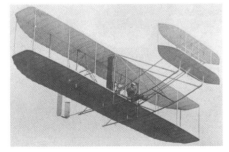

PAGE 27

PAGE 28

CHALLENGING ANSWERS

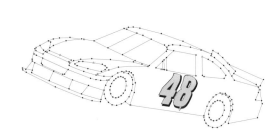

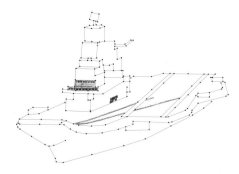

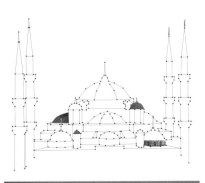

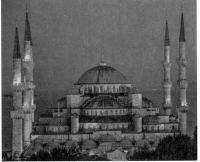

PAGE 29

PAGE 30

PAGE 31

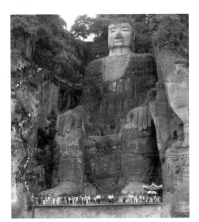

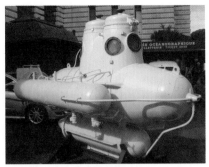

PAGE 32

PAGE 33

CHALLENGING ANSWERS

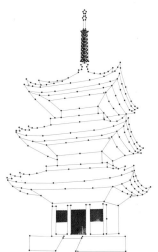 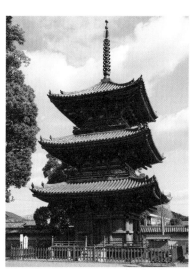

PAGE 34

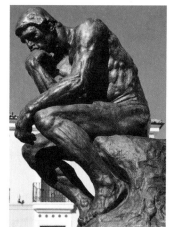

PAGE 35

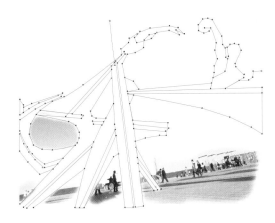

 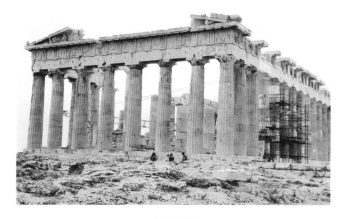

PAGE 36

PAGE 37

REALLY CHALLENGING ANSWERS

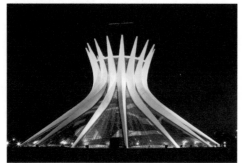

PAGE 38

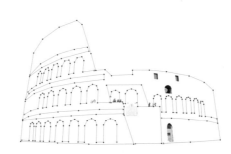
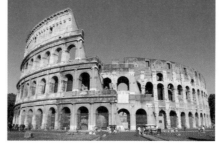

PAGE 39

PAGE 40

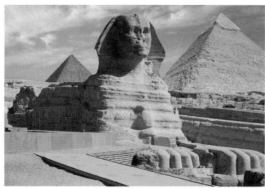

PAGE 41

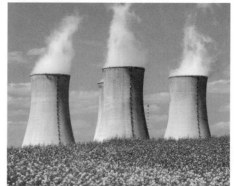

PAGE 42

REALLY CHALLENGING ANSWERS

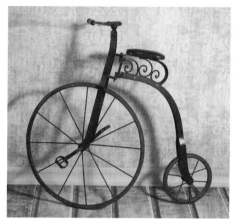

PAGE 43

PAGE 44

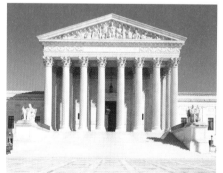

PAGE 45

PAGE 46

PAGE 47

REALLY CHALLENGING ANSWERS

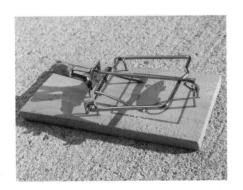

PAGE 48

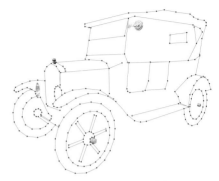

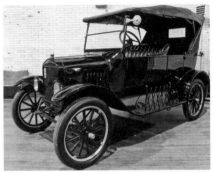

PAGE 49

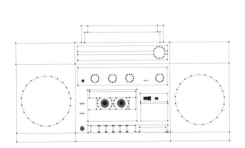

PAGE 50

PAGE 51

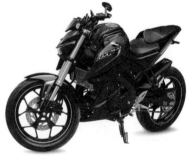

PAGE 52

REALLY CHALLENGING ANSWERS

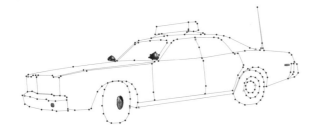

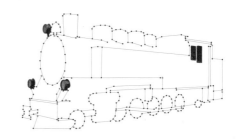

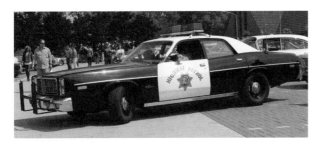

PAGE 53

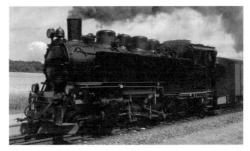

PAGE 54

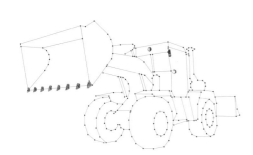

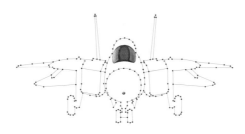

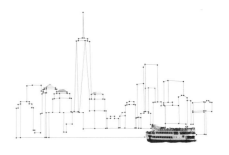

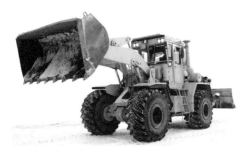

PAGE 55

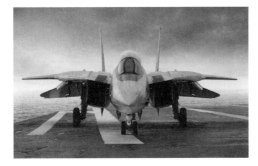

PAGE 56

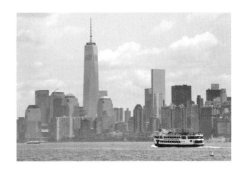

PAGE 57

REALLY CHALLENGING ANSWERS

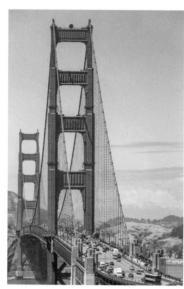

PAGE 58

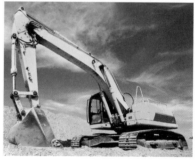

PAGE 59

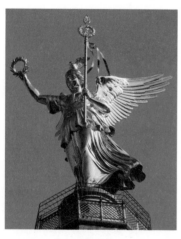
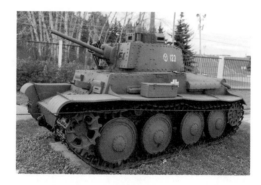
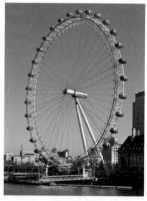

PAGE 60

PAGE 61

PAGE 62

REALLY CHALLENGING ANSWERS

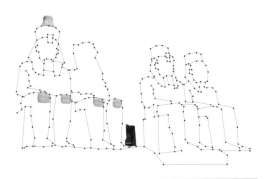

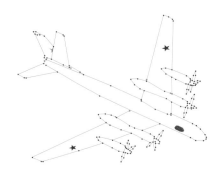

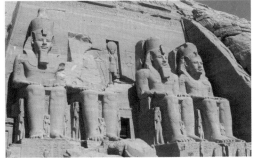

PAGE 63

PAGE 64

PAGE 67

PAGE 65

PAGE 66

REALLY CHALLENGING ANSWERS

PAGE 68

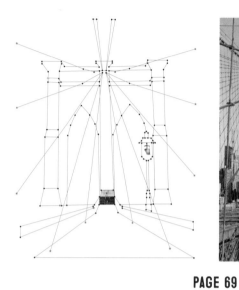

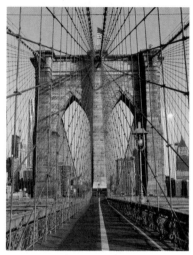

PAGE 69

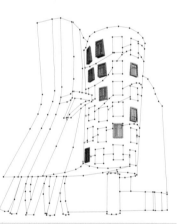

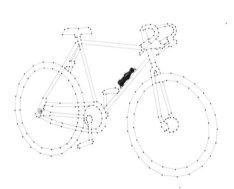

PAGE 70

PAGE 71

PAGE 72

SUPER-DUPER CHALLENGING ANSWERS

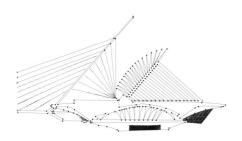

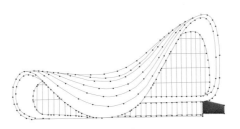

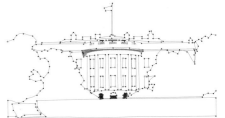

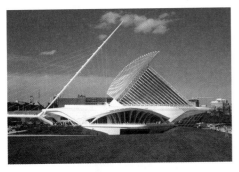

PAGE 73

PAGE 74

PAGE 75

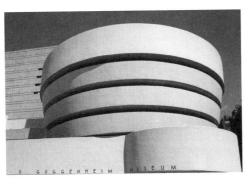

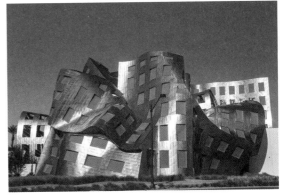

PAGE 76

PAGE 77

SUPER-DUPER CHALLENGING ANSWERS

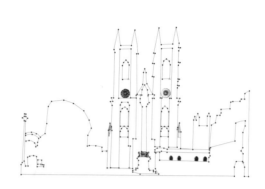

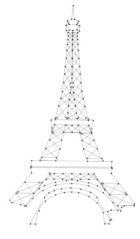

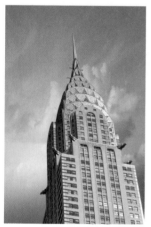

PAGE 78

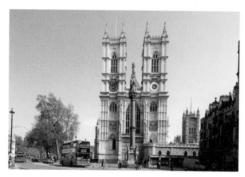

PAGE 79

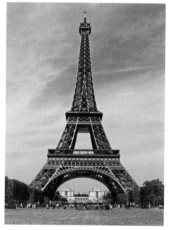

PAGE 80

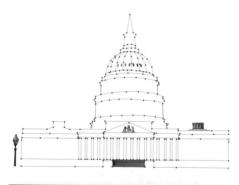

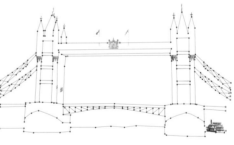

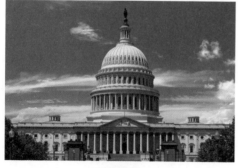

PAGE 81

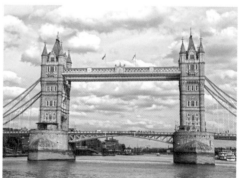

PAGE 82

SUPER-DUPER CHALLENGING ANSWERS

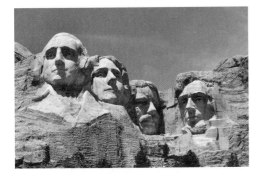

PAGE 83

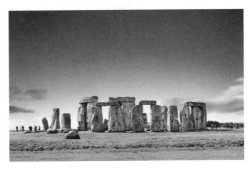

PAGE 84

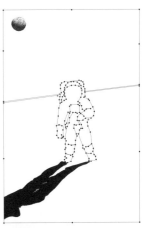

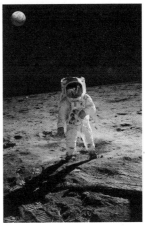

PAGE 85

PAGE 86

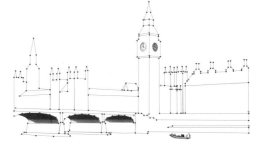

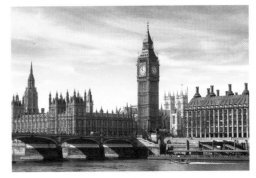

PAGE 87

SUPER-DUPER CHALLENGING ANSWERS

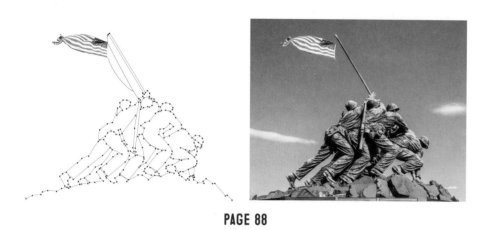

PAGE 88

PAGE 89

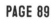

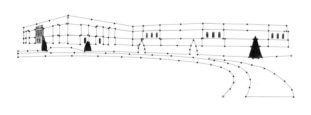

PAGE 90

PAGE 91

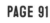

PAGE 92

SUPER-DUPER CHALLENGING ANSWERS

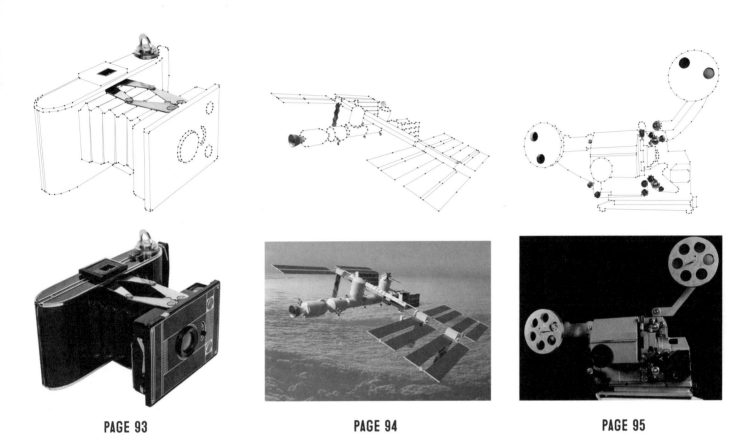

PAGE 93

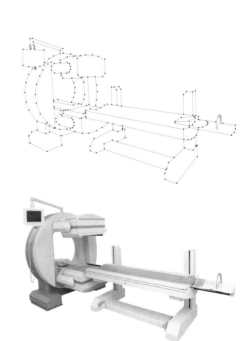

PAGE 94

PAGE 95

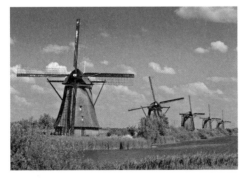

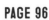

PAGE 96

PAGE 97

SUPER-DUPER CHALLENGING ANSWERS

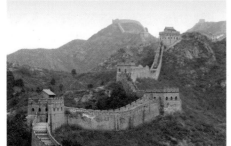

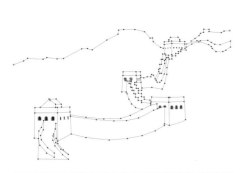

PAGE 98

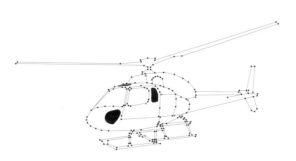

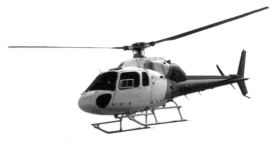

PAGE 99

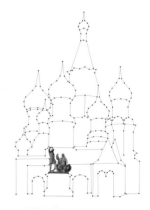

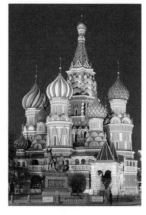

PAGE 100

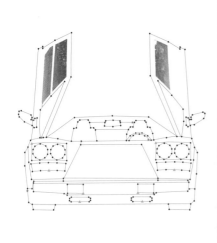

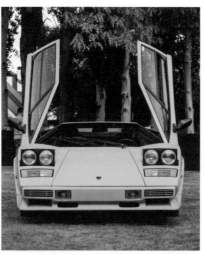

PAGE 101

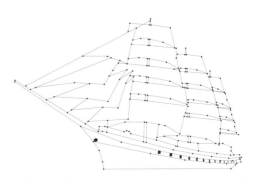

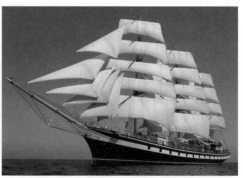

PAGE 102

SUPER-DUPER CHALLENGING ANSWERS

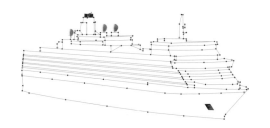

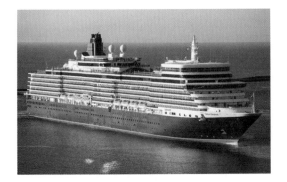

PAGE 103

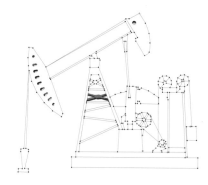

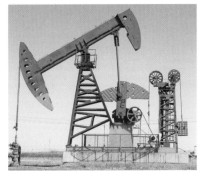

PAGE 104

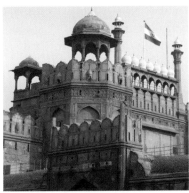

PAGE 105

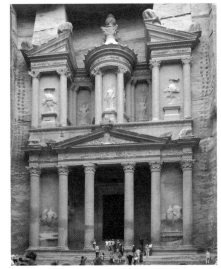

PAGE 106

PHOTO ACKNOWLEDGMENTS

Images from Shutterstock.com

Aleks49 (pages 61, 91, 118-bottom center, and 124-bottom center), AlexKZ (pages 55 and 117-bottom left), Alice-photo (pages 87 and 123-bottom right), Alvov (pages 102 and 126-bottom right), Anyaivanova (pages 54 and 117-top right), Nicola Bertolini (pages 11 and 108-bottom left), Justin Black (pages 84 and 123-top middle), Bork (pages 97 and 125-bottom right), Dan Breckwoldt (pages 10 and 108-top right), Orhan Cam (front cover and pages 75 and 121-top right), Caracarafoto (pages 101 and 126-bottom left), Castleski (pages 85 and 123-top right), Champiofoto (pages 40 and 114-top right), Marcel Clemens (pages 14 and 109-top left), Coprid (pages 92 and 124-bottom right), Elnur (pages 74 and 121-top middle), Ewais (pages 60 and 118-bottom left), Iakov Filimonov (pages 99 and 126-top middle), Stefano Garau (pages 103 and 127-top left), Gerisima (pages 50 and 116-bottom left), Glovatskiy (pages 68 and 120-top left), Godrick (pages 79 and 122-top middle), Matej Hudovernik (pages 4 and 107-top left), Hung Chung Chih (pages 98 and 126-top left), Igumnova Irina (pages 70, 77, 120-bottom left, and 121-bottom right), Anton Ivanov (pages 13 and 108-bottom right), Andrea Izzotti (pages 81 and 122-bottom left), Doug James (pages 29 and 112-top left), Lubica Jelenova (pages 16 and 109-bottom left), JeniFoto (pages 39 and 114-top middle), Budimir Jevtic (pages 59 and 118-top right), Kalachevstudio (pages 8 and 107-bottom right), Rattanasak Khuentana (pages 52 and 116-bottom right), Kislik (pages 65 and 119-bottom left), Roman Kurdo (pages 17 and 109-bottom middle), Pius Lee (pages 41 and 114-bottom left), Giancarlo Liguori (pages 82 and 122-bottom right), Lurii (pages 94 and 125-top middle), Majeczka (pages 80 and 122-top right), Aleksandra Malinina (pages 7 and 107-bottom left), Marianoblanco (pages 57 and 117-bottom right), Aleksandar Mijatovic (pages 93 and 125-top left), Luciano Mortula (pages 62 and 118-bottom right), Motive56 (pages 15 and 109-top right), Volkova Natalia (pages 100 and 126-top right), Kovalchuk Oleksandr (pages 45 and 115-bottom left), Oranzy (pages 12 and 108-bottom middle), Adam Parent (pages 47 and 115-bottom right), Sean Pavone (pages 88 and 124-top left), Pecold (pages 90 and 124-bottom left), Pisaphotography (pages 78 and 122-top left), PlusONE (pages 69 and 120-top right), Tatiana Popova (pages 71 and 120-bottom middle), Daniel Prudek (pages 42 and 114-bottm right), RSnapshotPhotos (pages 86 and 123-bottom left), Saiko3p (pages 6 and 107-top right), Sainum (pages 44 and 115-top right), Tinnaporn Sathapornnanont (pages 58 and 118-top left), Fedor Selivanov (back cover and pages 5 and 107-top middle), Ishkov Sergey (pages 95 and 125-top right), Vladislav Sinelnikov (pages 64 and 119-top right), Przemyslaw Skibinski (pages 63 and 119-top left), Ljupco Smokovski (pages 96 and 125-bottom left), Joseph Sohm (pages 73 and 121-top left), Sona9576033 (pages 83 and 123-top left), Nednapa Sopasuntorn (pages 66 and 119-bottom middle), Visut Suvanyuha (pages 46 and 115-bottom middle), Szefei (pages 105 and 127-bottom left), Taborsky (pages 43 and 115-top left), Dan Thornberg (pages 56 and 117-bottom middle), Tupungato (pages 51 and 116-bottom middle), UbjsP (pages 89 and 124-top right), VanderWolf Images (pages 53 and 117-top left), Roman Vukolov (pages 67 and 119-bottom right), Gary Yim (pages 38 and 114-top left), Zhengzaishuru (pages 104 and 127-top right), and Leonard Zhukovsky (pages 76 and 121-bottom left)

Images from Other Sources

663highland/Wikimedia Commons/adapted (pages 34 and 113-top left), Arriva436/Wikimedia Commons/adapted (pages 25 and 111-top middle), Karl Baron/Wikimedia Commons/adapted (pages 37 and 113-bottom right), Rosalba Casalnuovo CC By 2/www.flickr.com/photos/oh-barcelona/4681772122/adapted (page 36 and 113-bottom left), Chensiyuan/Wikimedia Commons/adapted (pages 18, 19, 109-bottom right, and 110-top left), Daderot/Wikimedia Commons/adapted (pages 20 and 110-top right), Leonardo da Vinci/Wikimedia Commons/adapted (pages 9 and 108-top left), Indian Navy/Wikimedia Commons/adapted (pages 30 and 112-top middle), Leandro Inocencio/Wikimedia Commons/adapted (pages 28 and 111-bottom right), Jesusccastillo/Wikimedia Commons/adapted (pages 35 and 113-top right), Jorge Láscar/www.flickr.com/photos/jlascar/8396803960/adapted (pages 31 and 112-top right), LibertyGroup25/Wikimedia Commons/adapted (pages 49 and 116-top right), Eduard Marmet/Wikimedia Commons/adapted (pages 23 and 110-bottom right), NASA (pages 12, 14, 21, 108-bottom middle, 109-top left, and 110-bottom left), Pete/www.flickr.com/photos/27760134@N03/6319573983/adapted (pages 26 and 111-top right), Charles Rondeau/Mousetrap Public Domain (pages 48 and 116-top left), Daniel Schwen/Wikimedia Commons/adapted (pages 72 and 120-bottom right), Ariel Steiner/Wikimedia Commons/adapted (pages 32 and 112-bottom left), Jeremy Thompson/www.flickr.com/photos/rollercoasterphilosophy/14695684189/in/album-72157645937376018//adapted (pages 22 and 110-bottom middle), Unknown/Records of the Office of the Chief Signal Officer/Wikimedia Commons (pages 27 and 111-bottom left), Vwexport1300/Wikimedia Commons/adapted (pages 24 and 111-top left), Berthold Werner/Wikimedia Commons/adapted (pages 106 and 127-bottom right), and Владимир Шеляпин/Wikimedia Commons/adapted (pages 33 and 112-bottom right)